Ruth Asawa

A Sculpting Life

Joan Schoettler

Illustrated by
Traci Van Wagoner

PELICAN PUBLISHING COMPANY
Gretna 2018

*The word "Pelican" and the depiction of a pelican are
trademarks of Pelican Publishing Company, Inc., and are
registered in the U.S. Patent and Trademark Office.*

Library of Congress Cataloging-in-Publication Data

Names: Schoettler, Joan, author. | Van Wagoner, Traci, illustrator.
Title: Ruth Asawa : a sculpting life / Joan Schoettler ; illustrated by Traci
 Van Wagoner.
Description: Gretna : Pelican Publishing Company, 2018. | Audience: Ages 3-8.
 | Audience: K to Grade 3.
Identifiers: LCCN 2018005595| ISBN 9781455623976 (hardcover : alk. paper)
 | ISBN 9781455623983 (ebook)
Subjects: LCSH: Asawa, Ruth—Juvenile literature. | Sculptors—United
 States—Biography. | Women sculptors—United States—Biography. | Japanese
 American sculptors—Biography.
Classification: LCC NB237.A82 S37 2018 | DDC 730.92 [B] —dc23
 LC record available at https://lccn.loc.gov/2018005595

*Artwork depicted in illustrations and photographs copyright © Estate of
Ruth Asawa*

Printed in Malaysia

Published by Pelican Publishing Company, Inc.
1000 Burmaster Street, Gretna, Louisiana 70053
www.pelicanpub.com

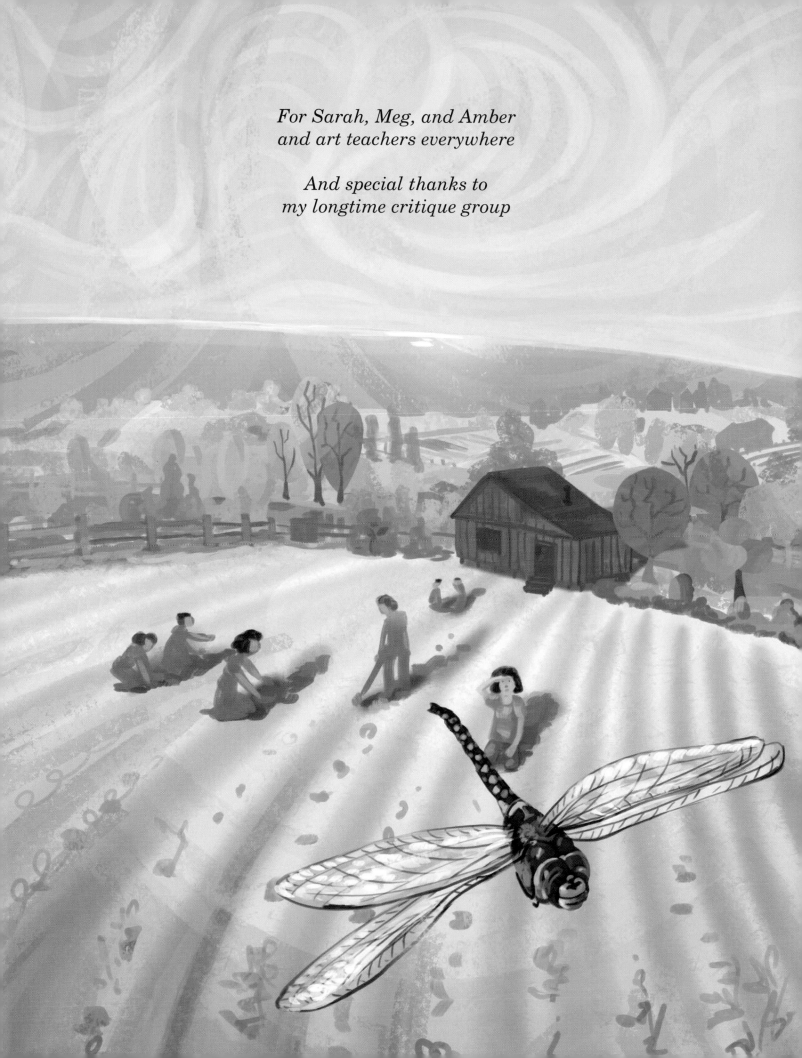

For Sarah, Meg, and Amber
and art teachers everywhere

And special thanks to
my longtime critique group

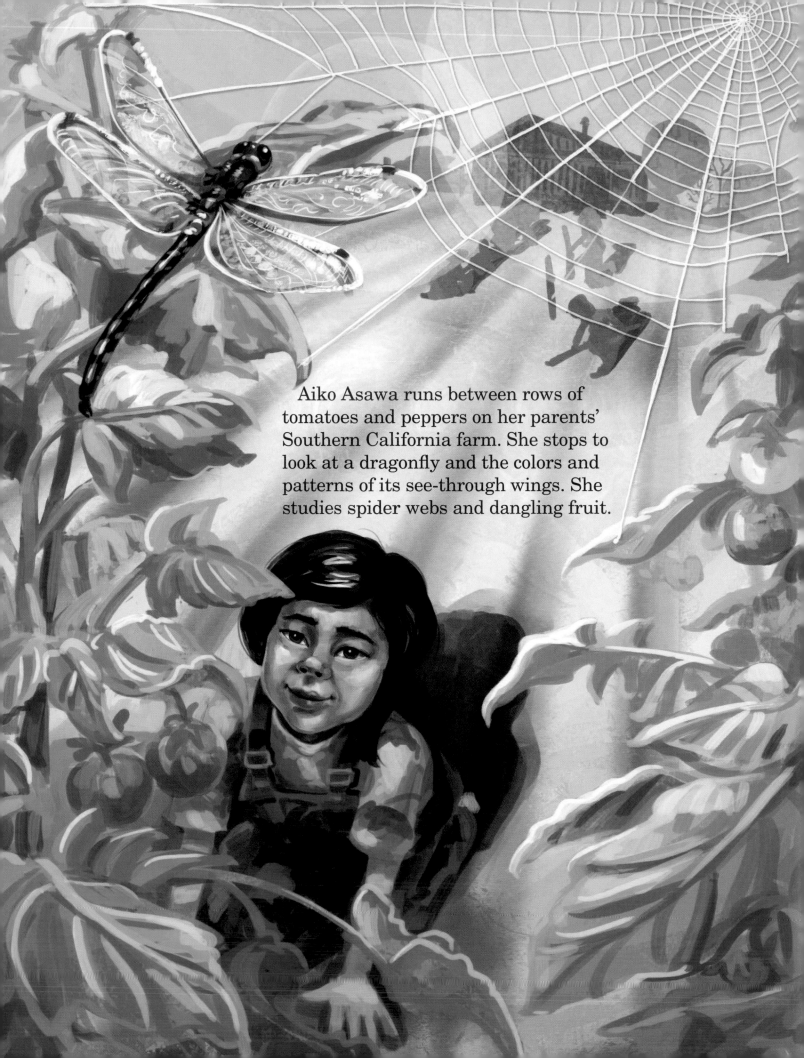

Aiko Asawa runs between rows of tomatoes and peppers on her parents' Southern California farm. She stops to look at a dragonfly and the colors and patterns of its see-through wings. She studies spider webs and dangling fruit.

Her toes touch the ground as her legs dangle over the edge of a horse-drawn leveler. She uses her toes to draw and delights in making wavy lines and hourglass shapes.

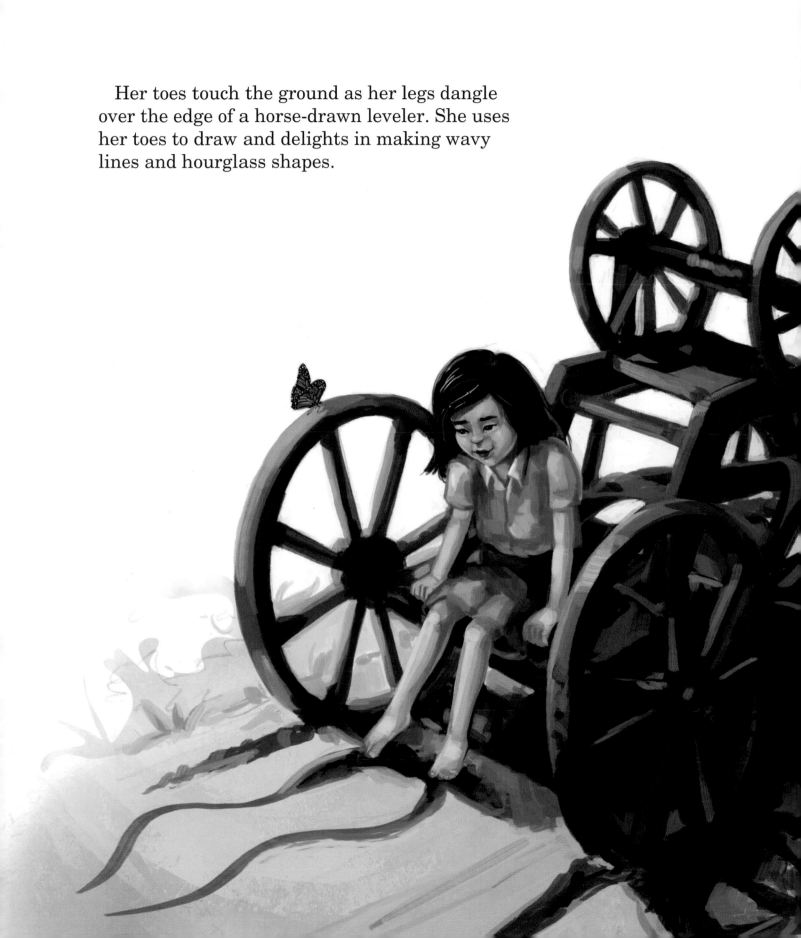

At home, Aiko speaks Japanese and is called by her Japanese name. At school, she is known as Ruth, her American name, and signs *Ruth* on her polar bear picture. She is proud when it is put up for display.

Her third-grade teacher encourages Ruth's artistic talent. Ruth wins a school competition for her drawing of the Statue of Liberty, representing what it means to be an American.

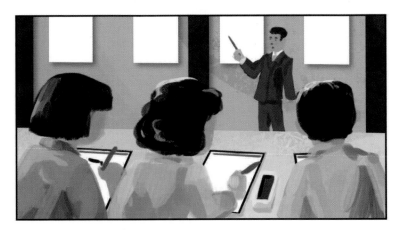

On Saturdays, Ruth attends Japanese school with other Japanese-American children. "Empty space is as important as strokes," her calligraphy teacher tells her. She paints black ink on white paper, with single strokes. She studies lines, curves, and spaces around her.

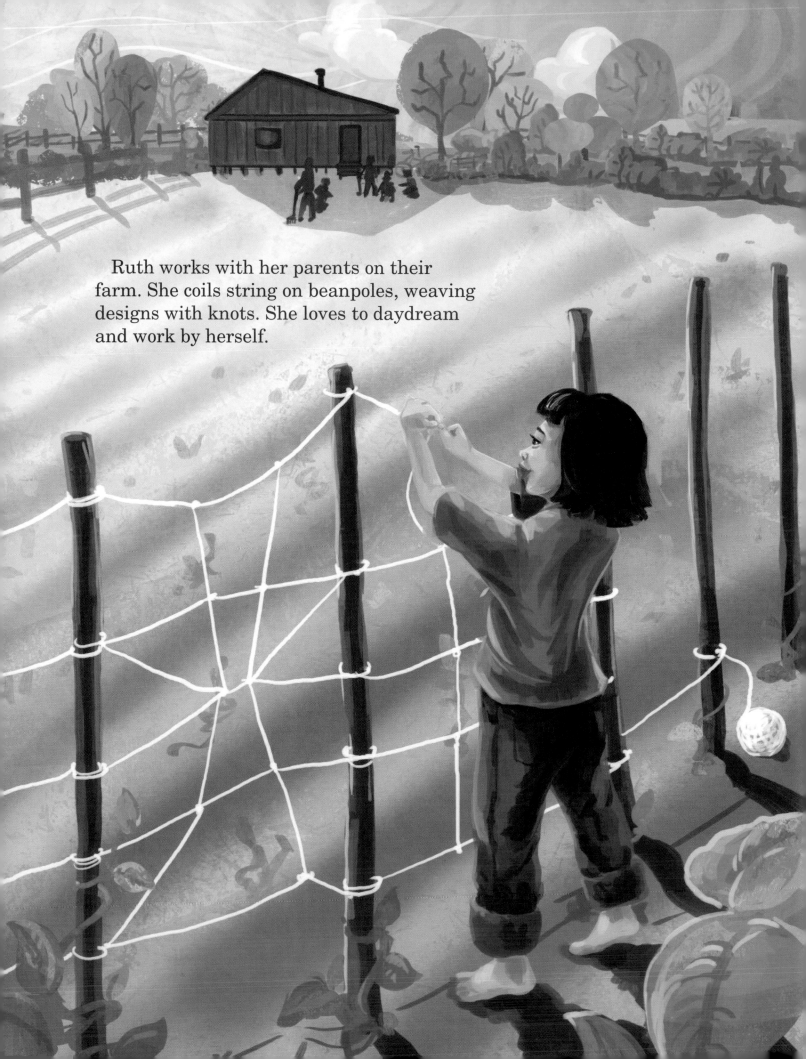

Ruth works with her parents on their farm. She coils string on beanpoles, weaving designs with knots. She loves to daydream and work by herself.

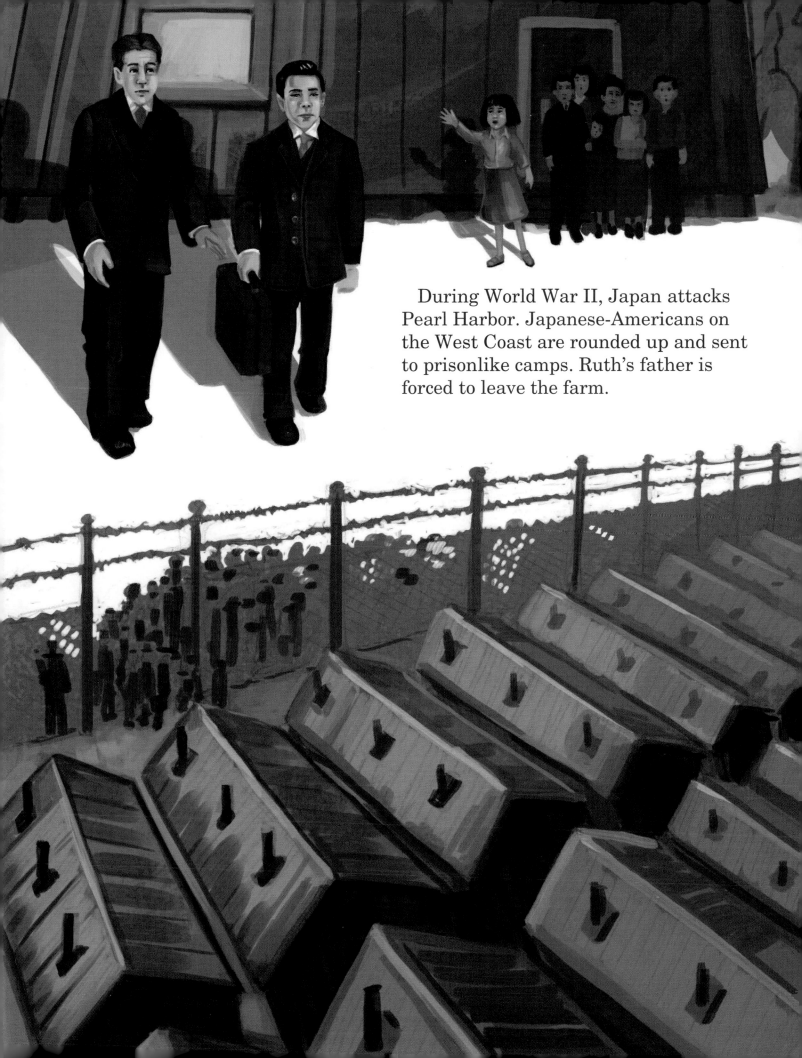

During World War II, Japan attacks Pearl Harbor. Japanese-Americans on the West Coast are rounded up and sent to prisonlike camps. Ruth's father is forced to leave the farm.

A short time later, Ruth carries her own small suitcase and boards a bus with her mother, brothers, and sisters.

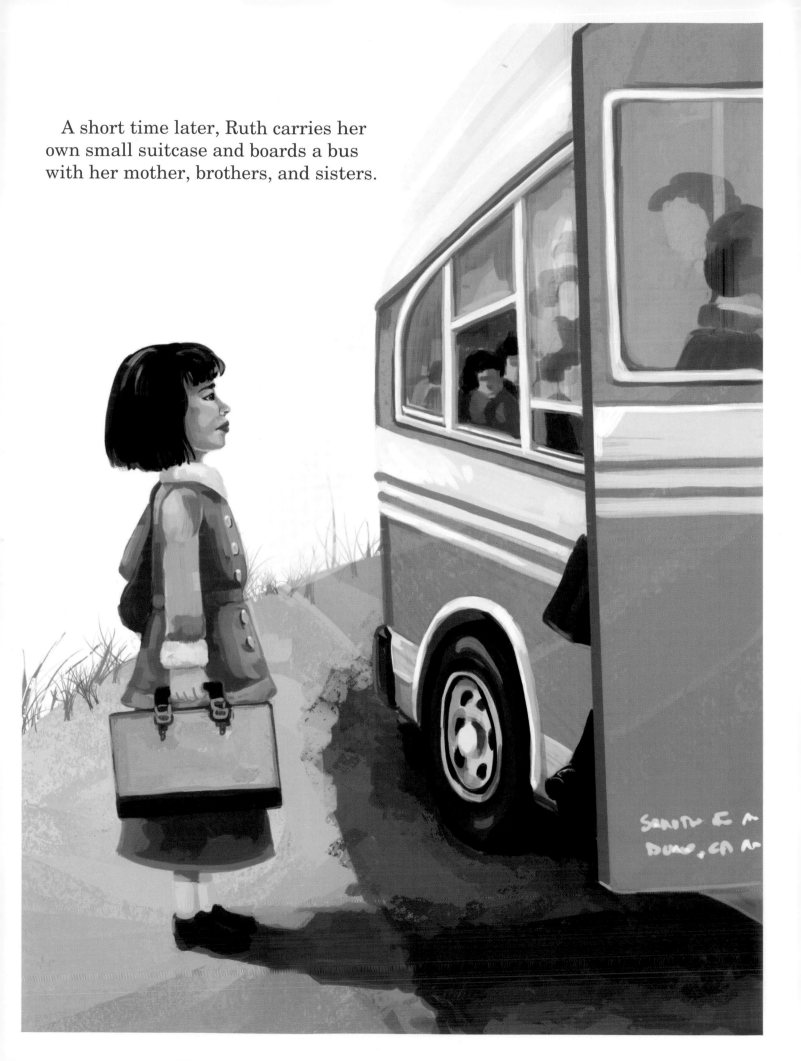

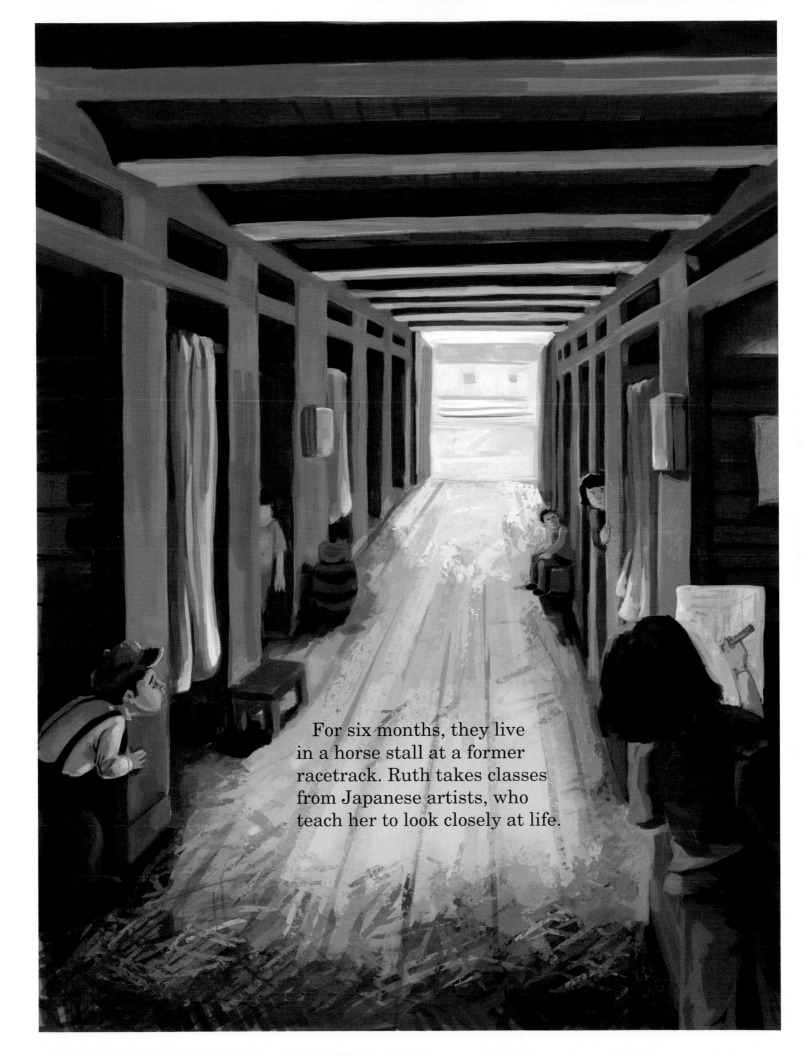

For six months, they live
in a horse stall at a former
racetrack. Ruth takes classes
from Japanese artists, who
teach her to look closely at life.

Again, Ruth and her family are moved, far from the coast.

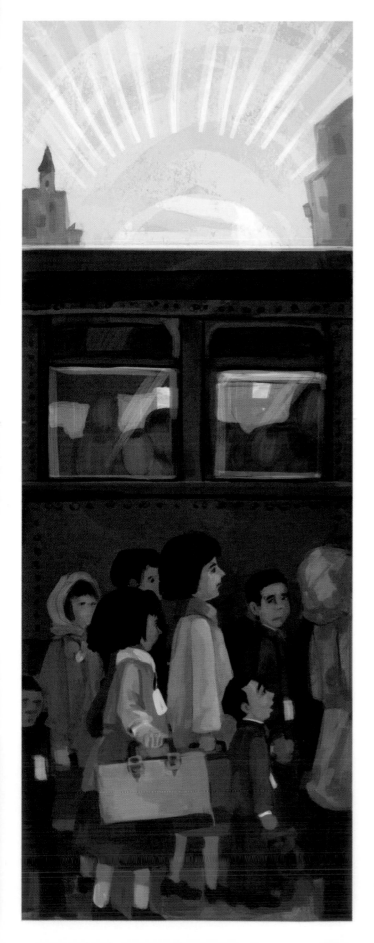

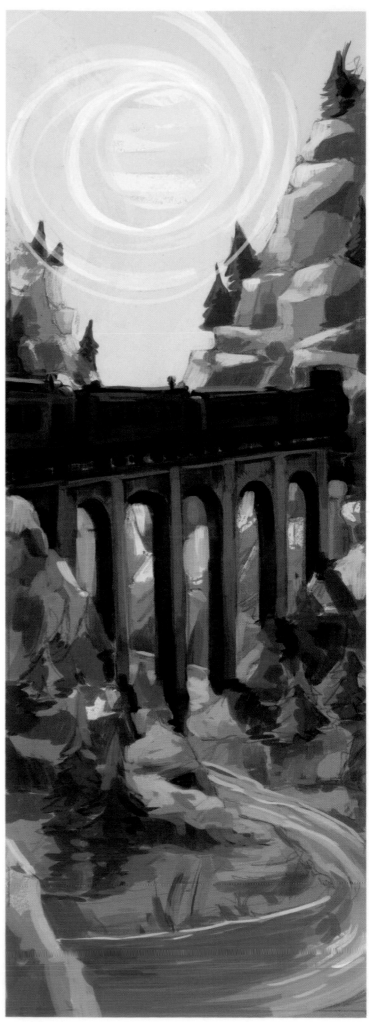

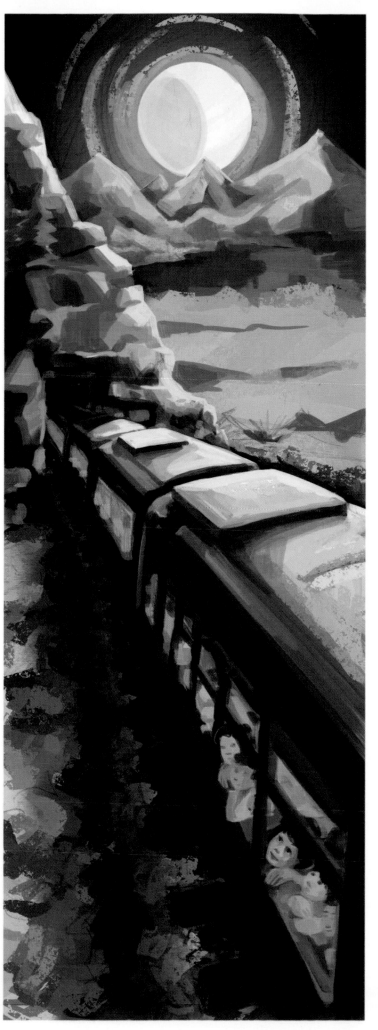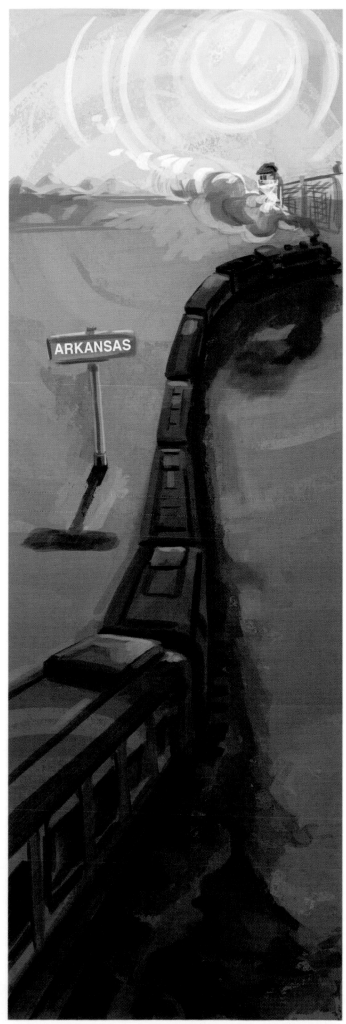

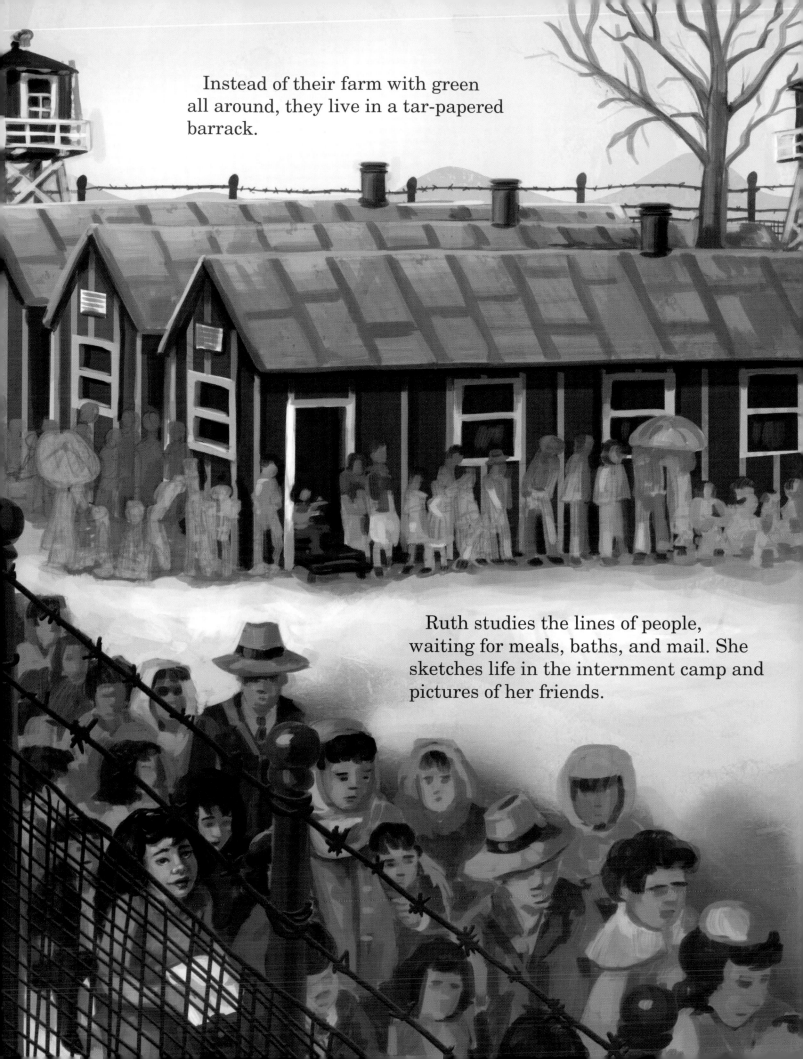

Instead of their farm with green all around, they live in a tar-papered barrack.

Ruth studies the lines of people, waiting for meals, baths, and mail. She sketches life in the internment camp and pictures of her friends.

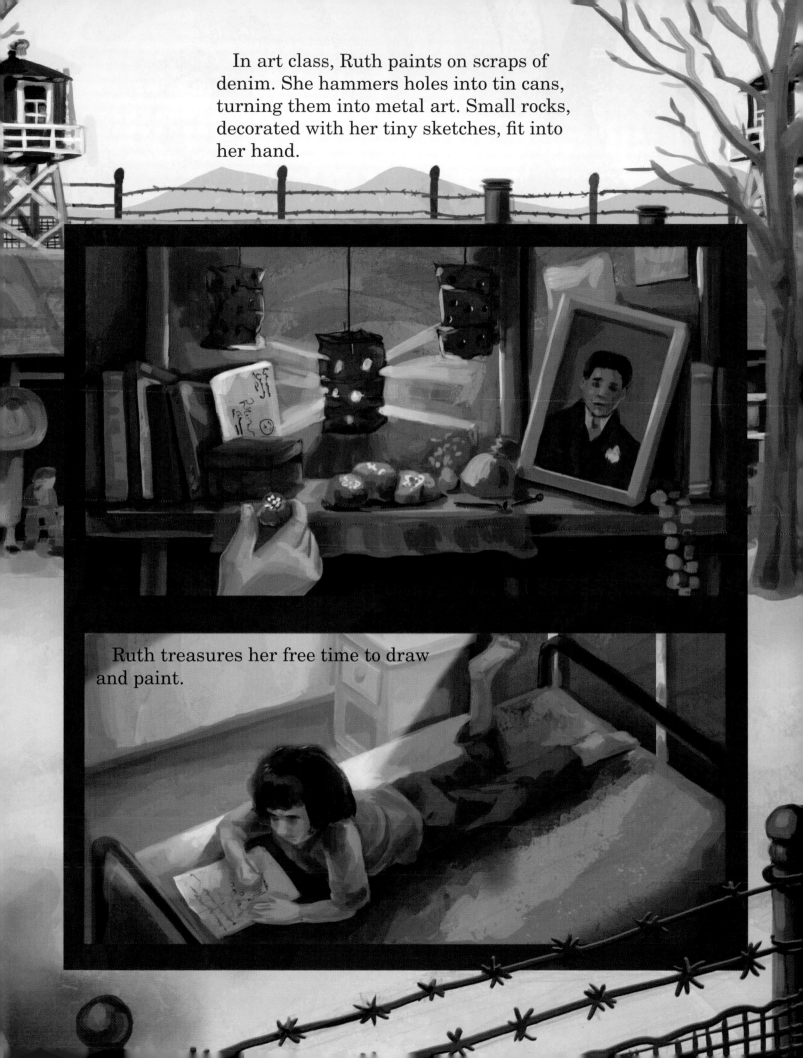

In art class, Ruth paints on scraps of denim. She hammers holes into tin cans, turning them into metal art. Small rocks, decorated with her tiny sketches, fit into her hand.

Ruth treasures her free time to draw and paint.

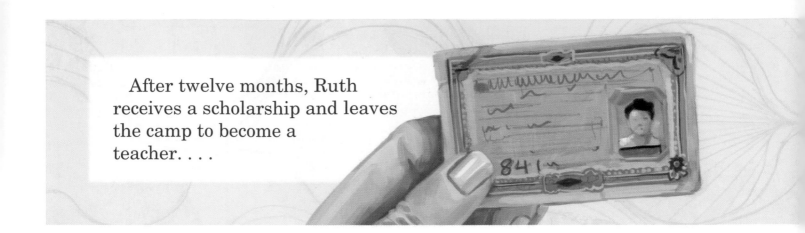

After twelve months, Ruth receives a scholarship and leaves the camp to become a teacher. . . .

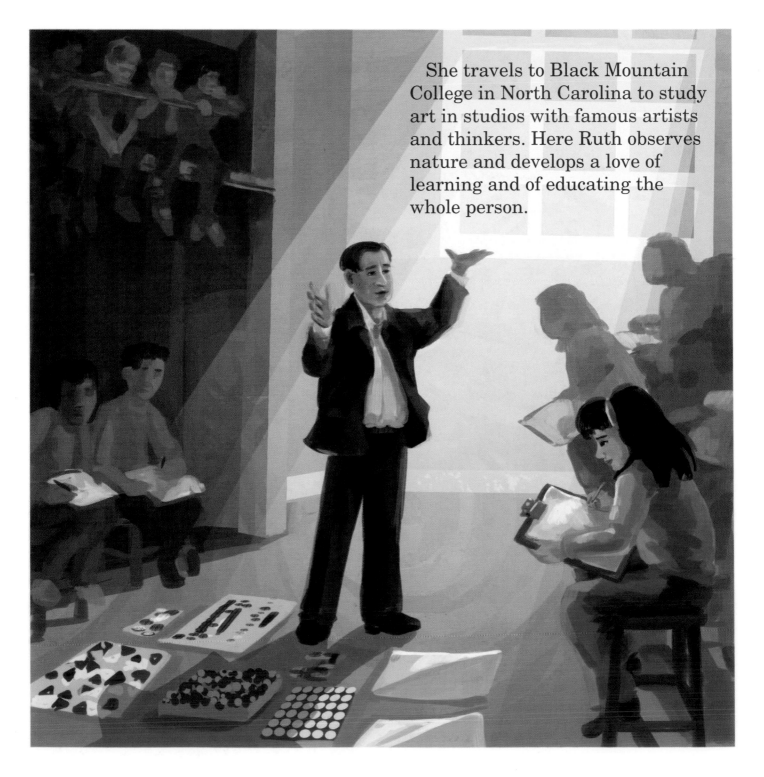

She travels to Black Mountain College in North Carolina to study art in studios with famous artists and thinkers. Here Ruth observes nature and develops a love of learning and of educating the whole person.

. . . Milwaukee State Teachers College trains her to be a teacher, but when Ruth is close to finishing her degree, she realizes her Japanese ancestry will make it hard for her to be hired. She leaves without a diploma.

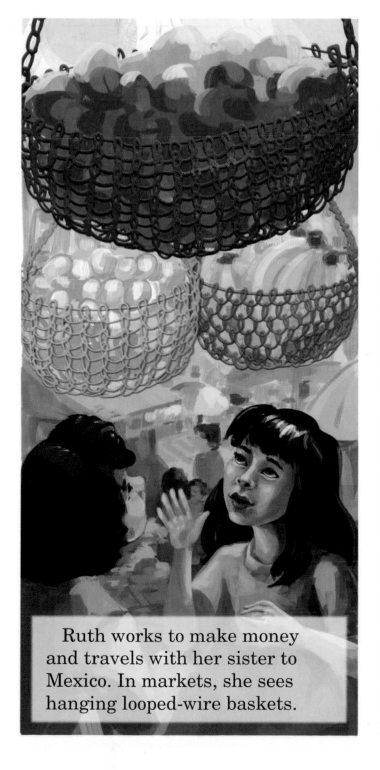

Ruth works to make money and travels with her sister to Mexico. In markets, she sees hanging looped-wire baskets.

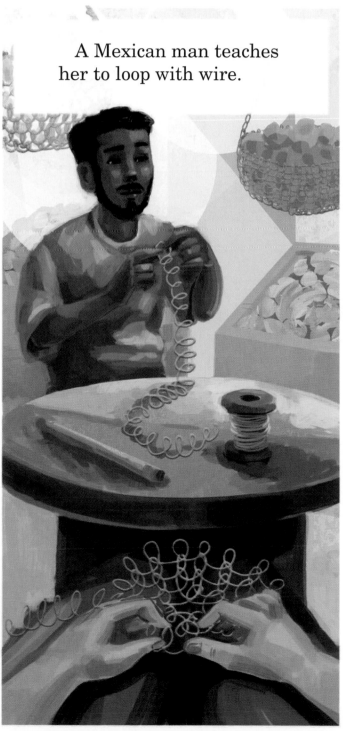

A Mexican man teaches her to loop with wire.

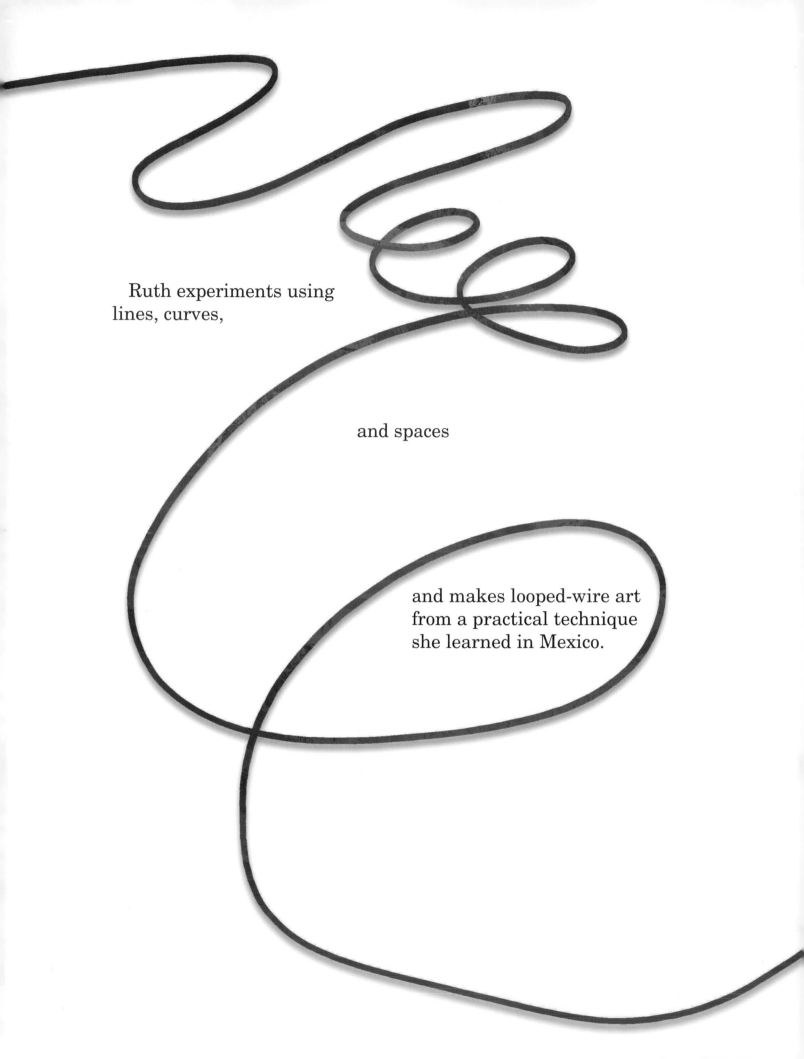

Ruth experiments using lines, curves,

and spaces

and makes looped-wire art from a practical technique she learned in Mexico.

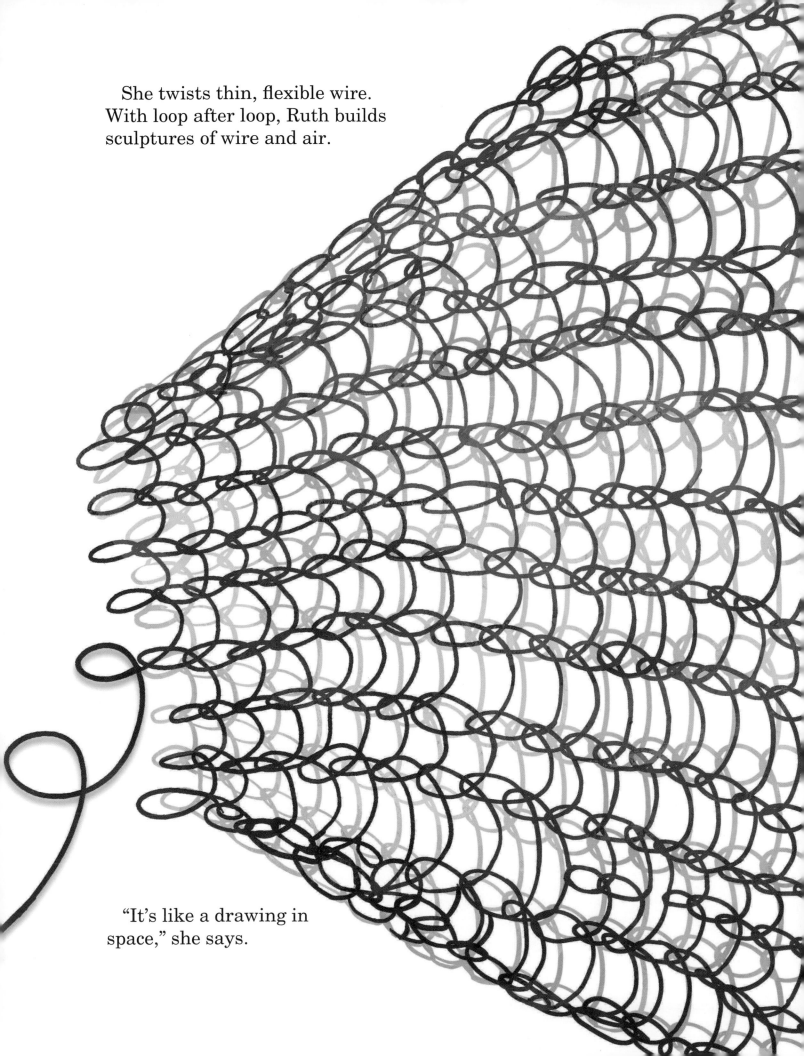

She twists thin, flexible wire.
With loop after loop, Ruth builds
sculptures of wire and air.

"It's like a drawing in
space," she says.

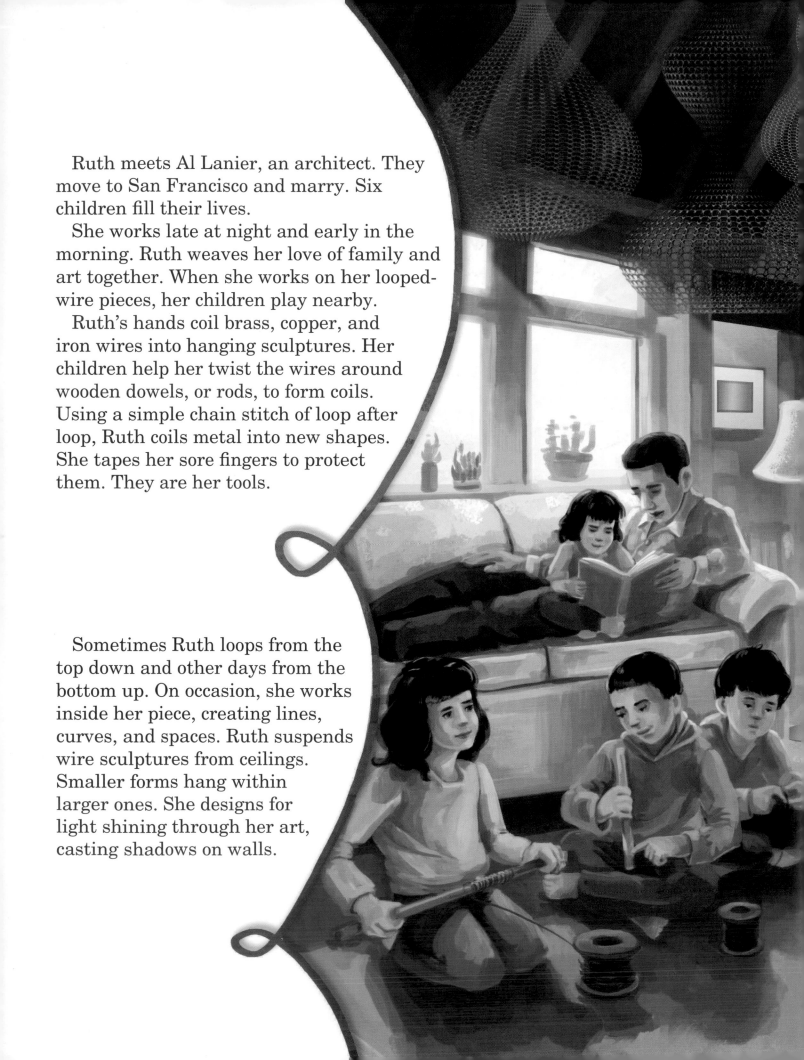

Ruth meets Al Lanier, an architect. They move to San Francisco and marry. Six children fill their lives.

She works late at night and early in the morning. Ruth weaves her love of family and art together. When she works on her looped-wire pieces, her children play nearby.

Ruth's hands coil brass, copper, and iron wires into hanging sculptures. Her children help her twist the wires around wooden dowels, or rods, to form coils. Using a simple chain stitch of loop after loop, Ruth coils metal into new shapes. She tapes her sore fingers to protect them. They are her tools.

Sometimes Ruth loops from the top down and other days from the bottom up. On occasion, she works inside her piece, creating lines, curves, and spaces. Ruth suspends wire sculptures from ceilings. Smaller forms hang within larger ones. She designs for light shining through her art, casting shadows on walls.

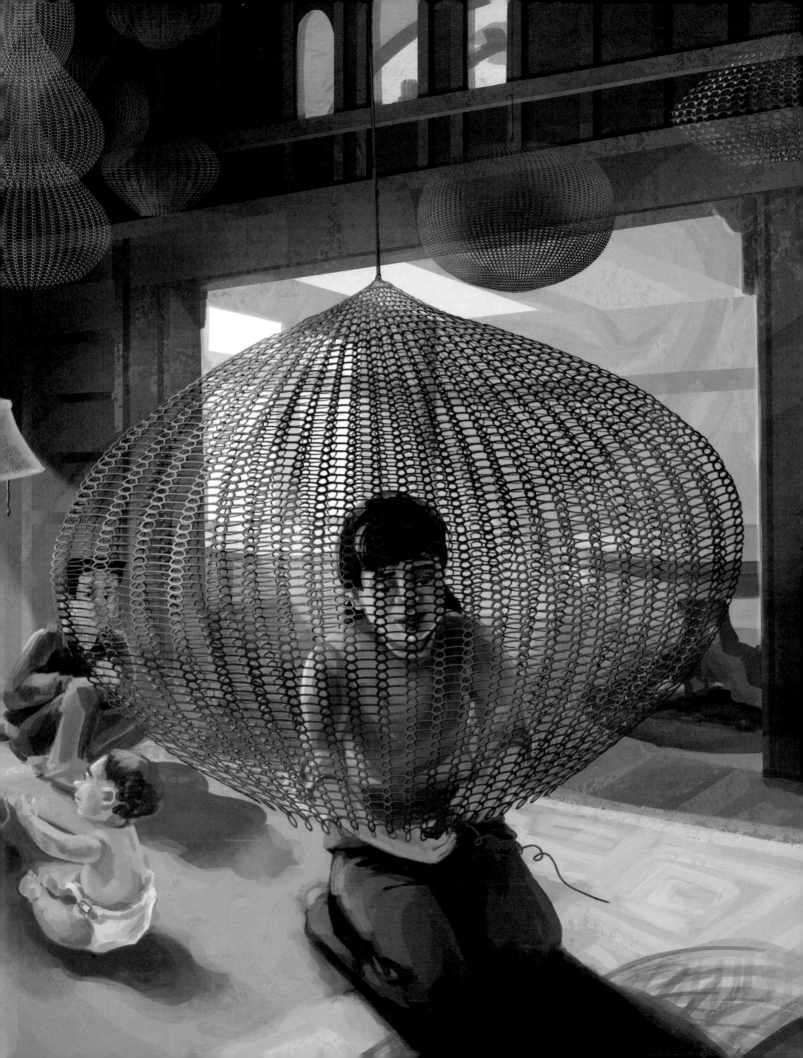

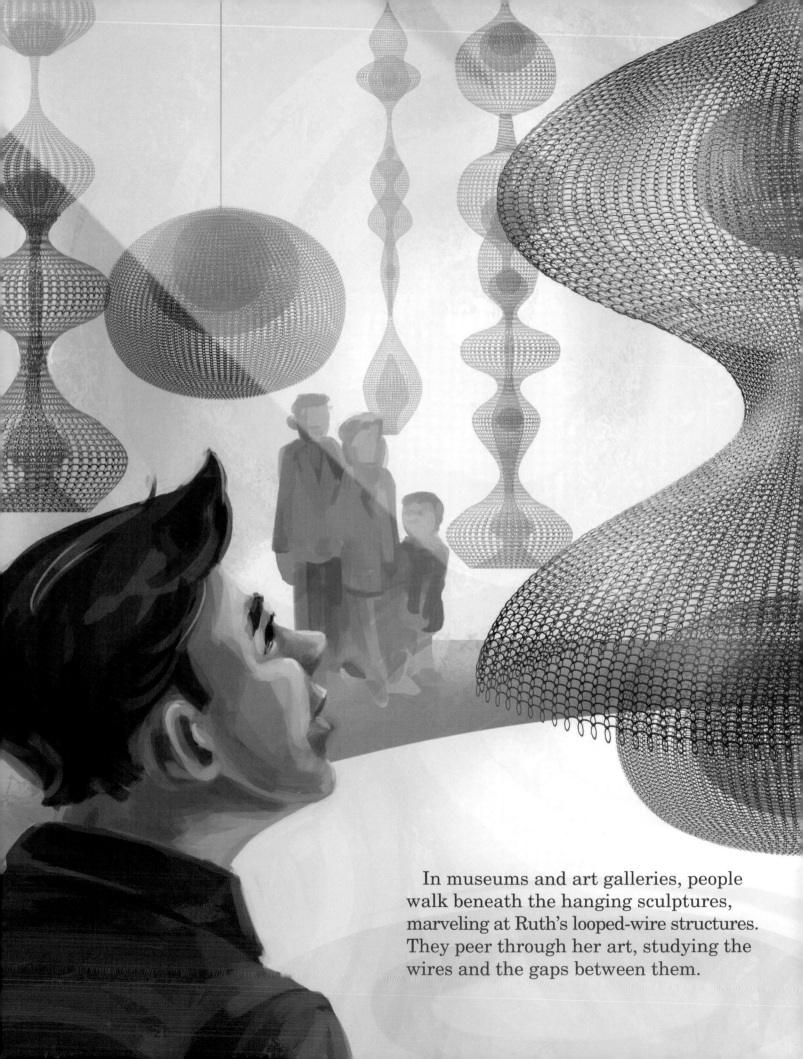

In museums and art galleries, people walk beneath the hanging sculptures, marveling at Ruth's looped-wire structures. They peer through her art, studying the wires and the gaps between them.

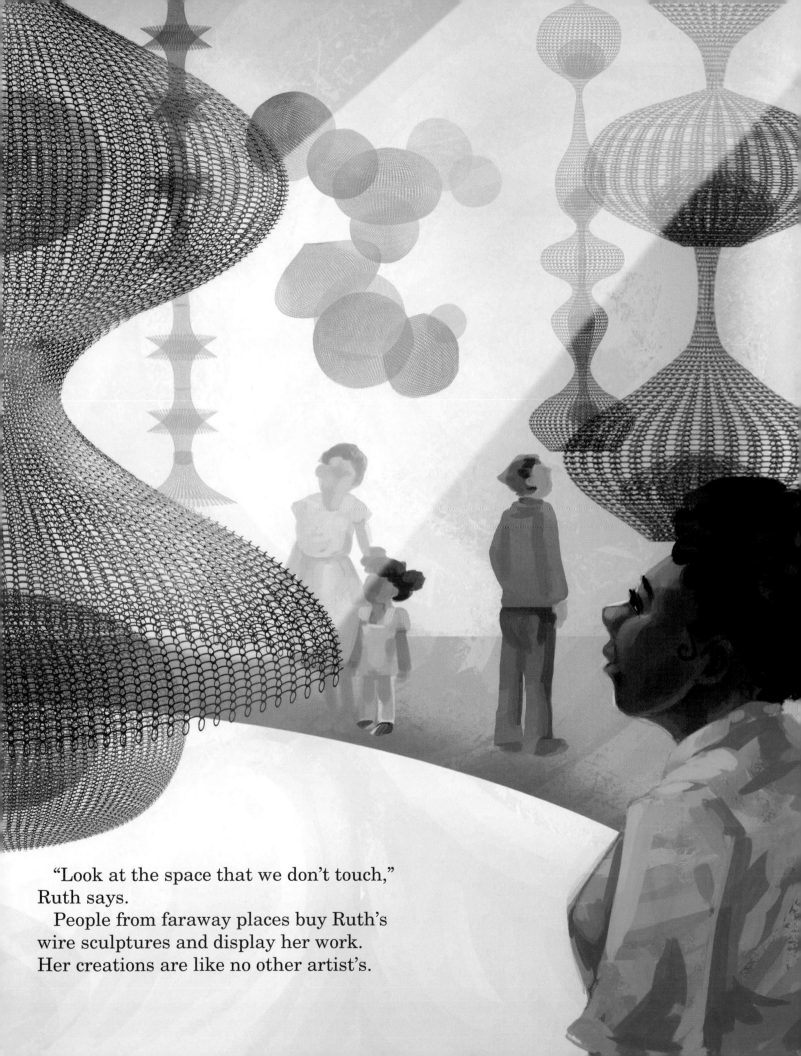

"Look at the space that we don't touch,"
Ruth says.

People from faraway places buy Ruth's
wire sculptures and display her work.
Her creations are like no other artist's.

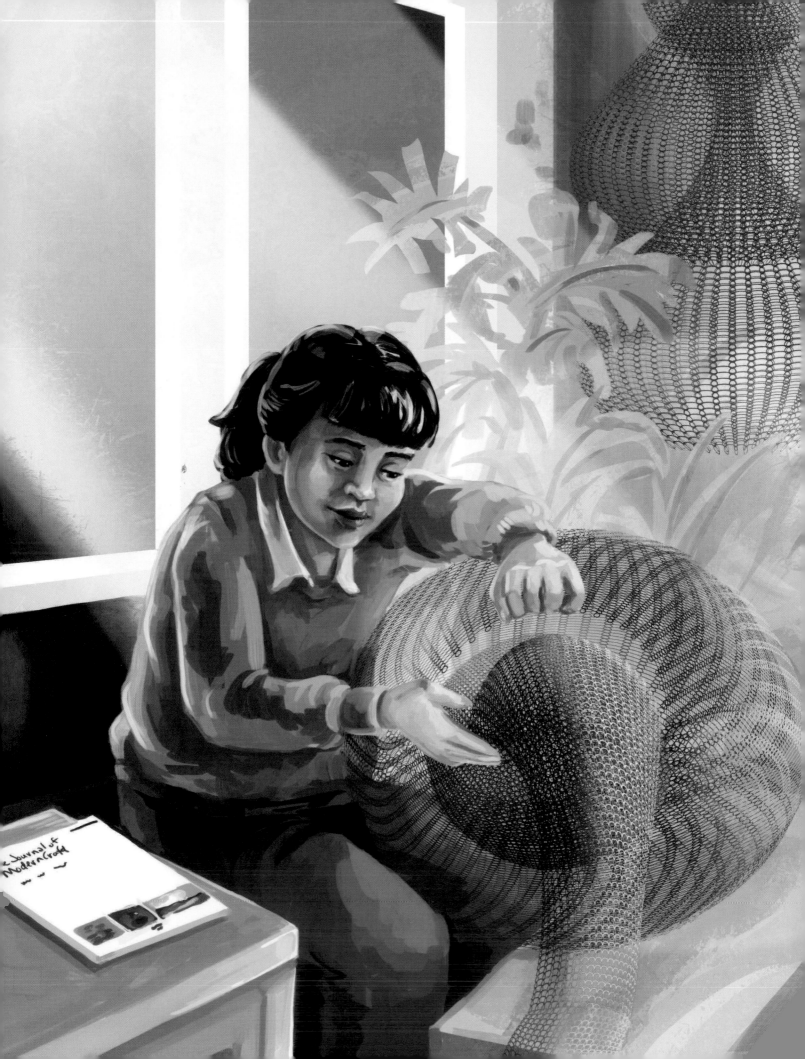

Some early reviews of Ruth's work call it women's craftwork or Japanese influenced. Ruth ignores these reviews. She continues looping and dividing, thinking about the empty spaces within her creations. Ruth receives many art awards and honorary degrees.

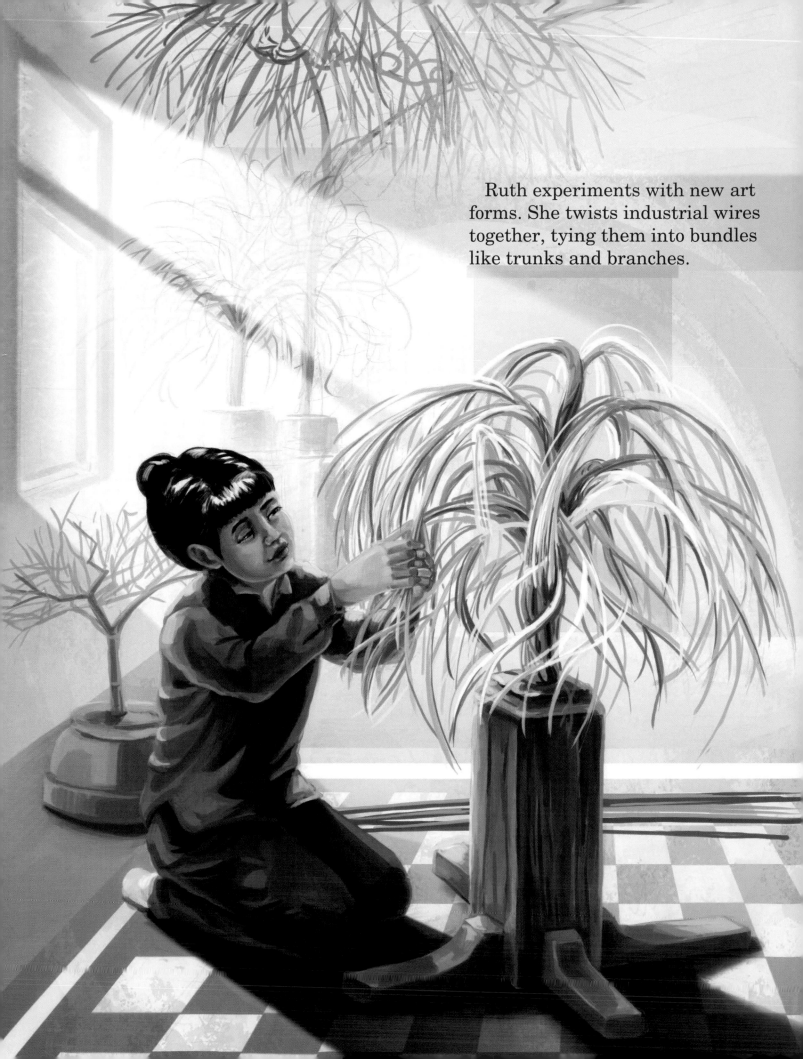

Ruth experiments with new art forms. She twists industrial wires together, tying them into bundles like trunks and branches.

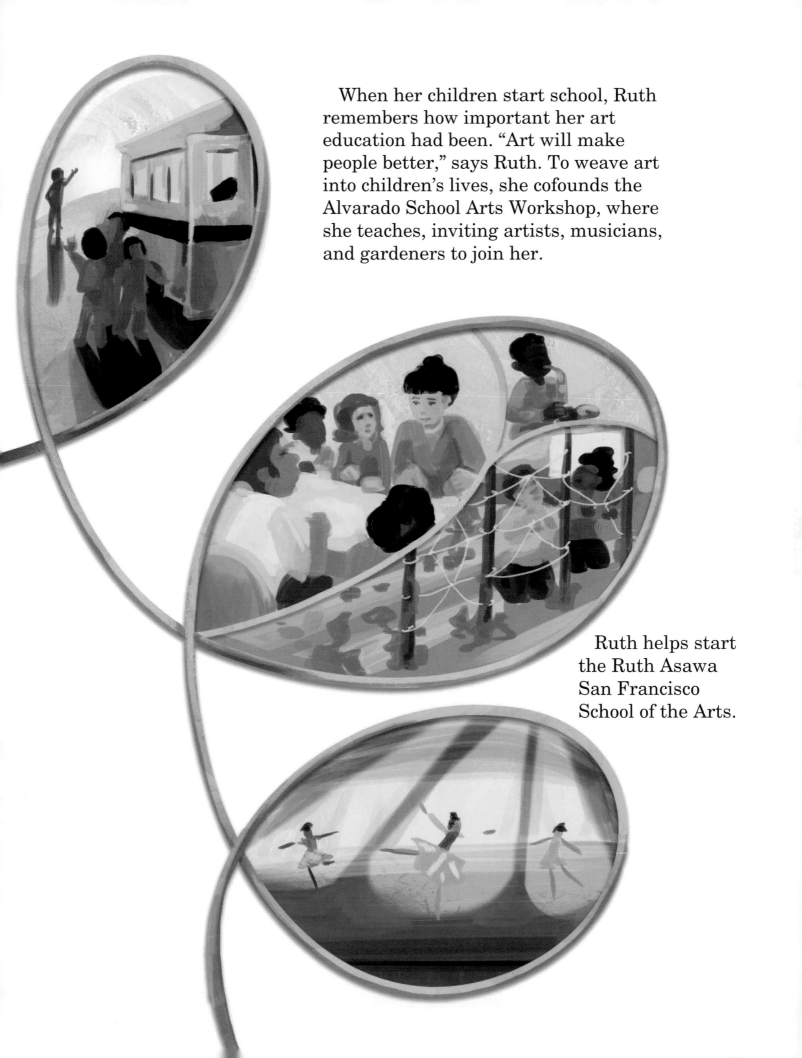

When her children start school, Ruth remembers how important her art education had been. "Art will make people better," says Ruth. To weave art into children's lives, she cofounds the Alvarado School Arts Workshop, where she teaches, inviting artists, musicians, and gardeners to join her.

Ruth helps start the Ruth Asawa San Francisco School of the Arts.

Andrea, the fountain in Ghirardelli Square, is Ruth's first public commission. Because it is close to the bay, and she wants to appeal to children, Ruth sculpts two mermaids and a merbaby. Large frogs and playful turtles swim and sun themselves.

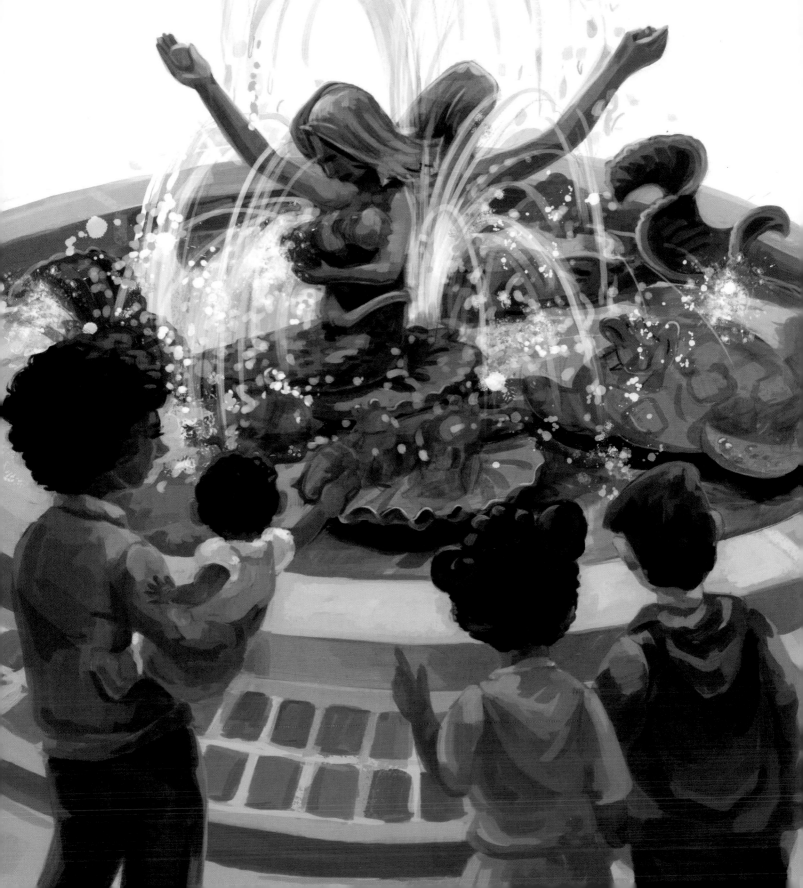

Ruth invites the community to help create her large projects. Rolling, twisting, and sculpting baker's clay, schoolchildren fashion self-portraits, buildings, and local landmarks. Ruth has their pieces cast into bronze to create the San Francisco Fountain.

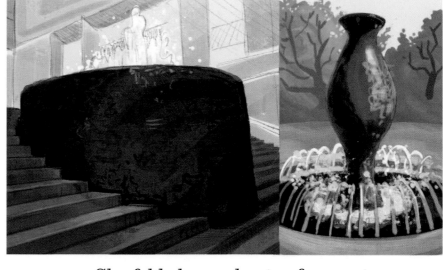

She folds large sheets of paper to design structures for public fountains, and later the models are cast in steel.

Ruth becomes known as the "Fountain Lady" of San Francisco.

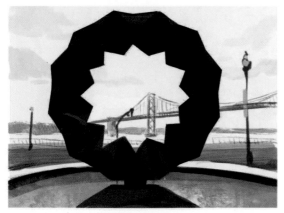

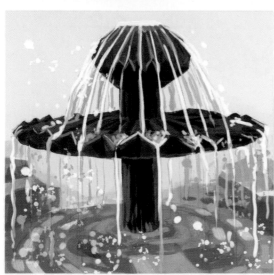

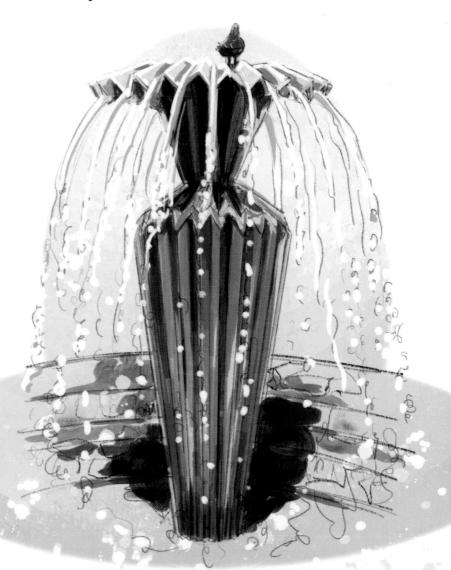

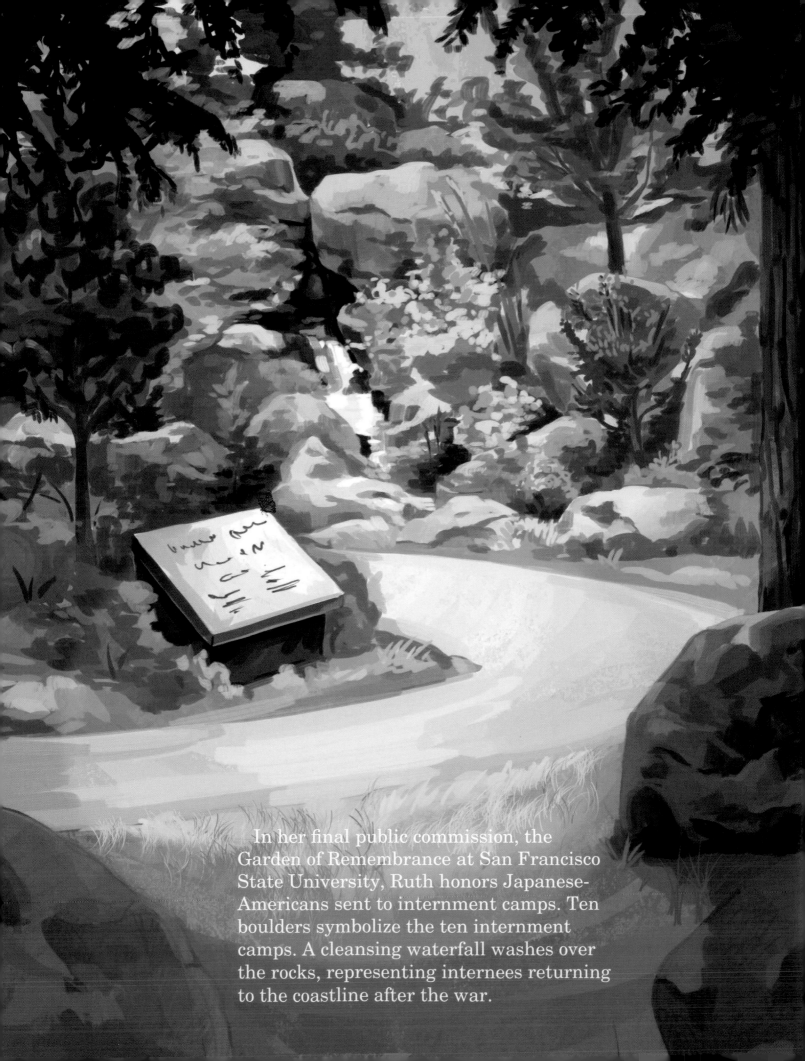

In her final public commission, the Garden of Remembrance at San Francisco State University, Ruth honors Japanese-Americans sent to internment camps. Ten boulders symbolize the ten internment camps. A cleansing waterfall washes over the rocks, representing internees returning to the coastline after the war.

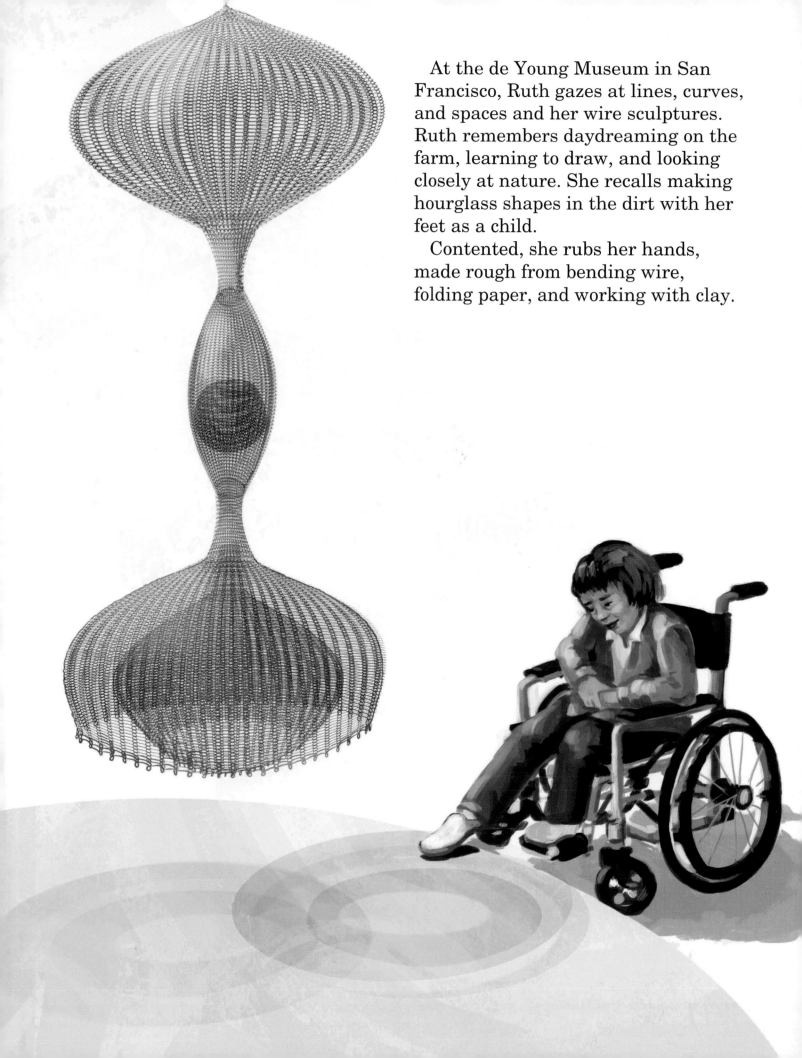

At the de Young Museum in San Francisco, Ruth gazes at lines, curves, and spaces and her wire sculptures. Ruth remembers daydreaming on the farm, learning to draw, and looking closely at nature. She recalls making hourglass shapes in the dirt with her feet as a child.

Contented, she rubs her hands, made rough from bending wire, folding paper, and working with clay.

"If you put a seed in the ground, the seed doesn't stop growing. You put it in the soil, and that bulb grows every second that it's attached to the earth. That's why I think that every minute we're attached to the earth, we should be doing something." —Ruth Asawa

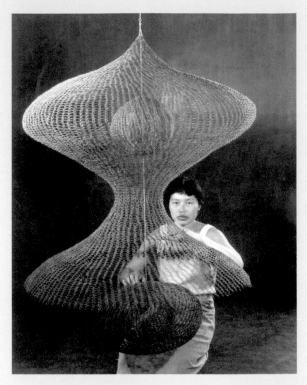

Below: (Nat Farbman/The LIFE Picture Collection/Getty Images)

Top right: *Ruth kneeling behind a hanging looped-wire sculpture, circa 1957* (© Imogen Cunningham Trust. All rights reserved.)

Center right: *Ruth Asawa, 1957* (© Imogen Cunningham Trust. All rights reserved.)

Bottom right: *Ruth Asawa, 1957* (© Imogen Cunningham Trust. All rights reserved.)

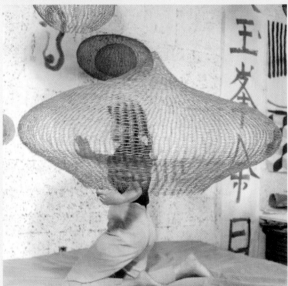

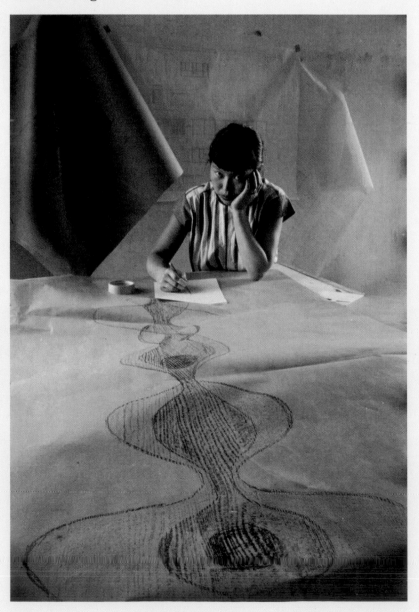

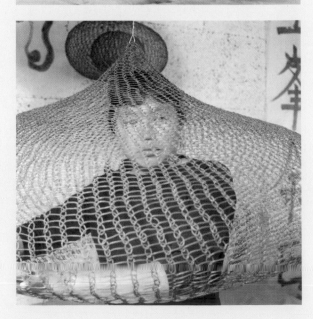

Author's Note

Ruth Asawa spent her life as an artist, educator, and arts advocate. She believed that all children should be exposed to art and that professional artists should teach and work with students in classrooms. One time, Ruth had more than one hundred children use common baker's clay to create scenes of daily life in San Francisco. She arranged the pieces of sculptured dough into a cylinder that was later cast in bronze. It became the San Francisco Fountain. This picture book is written in gratitude for all the gifts that Ruth Asawa shared.

Public Commissions

1968 *Andrea,* the Mermaid Fountain at Ghirardelli Square, San Francisco, CA

1973 *San Francisco Fountain,* near Union Square, San Francisco, CA

1976 *Buchanan Mall Fountain,* Japantown, San Francisco, CA

1986 *Aurora,* origami-inspired fountain at Bayside Plaza, San Francisco, CA

1988 *History of Wine,* cast bronze fountain at Beringer Winery, St. Helena, CA

1994 *Japanese-American Internment Memorial Sculpture,* San Jose, CA

2002 *Garden of Remembrance,* San Francisco State University, CA

In 1982, February 12 was declared Ruth Asawa Day in San Francisco.

Asawa was born on January 24, 1926, in California. She died on August 6, 2013, at her home in San Francisco.